CONTEMPORARY GLASS
COLOR, LIGHT & FORM

RAY LEIER

JAN PETERS

KEVIN WALLACE

CONTEMPORARY GLASS

COLOR, LIGHT & FORM

GUILD Publishing, Madison, Wisconsin
Distributed by North Light Books, Cincinnati, Ohio

Contemporary Glass
Color, Light & Form

Ray Leier
Jan Peters
Kevin Wallace

Copyright © 2001 by GUILD Publishing

Chief Editorial Officer: Katie Kazan
Design and production: Cheryl Smallwood-Roberts
Editor: Anne McKenna

All rights reserved. Artwork in this publication is protected by copyright and may not be reproduced in any form without permission of the artist. No part of this publication may be reproduced or transmitted in any form or by any means, electronic or mechanical, including photocopy, recording or any other information storage and retrieval system, without prior permission in writing from the publisher.

07 06 05 04 03 02 01 7 6 5 4 3 2 1

Published by
GUILD Publishing, an imprint of Ashford.com
931 East Main Street
Madison, WI 53703 USA
TEL 608-257-2590 • TEL 877-284-8453 • FAX 608-227-4179

Distributed to the trade and art markets in North America by
North Light Books, an imprint of F&W Publications, Inc.
1507 Dana Avenue
Cincinnati, OH 45207
TEL 800-289-0963

Printed in Singapore

ISBN 1-893164-10-1

FRONT COVER ARTWORK: William Morris, *Arna Buffalo Situla,* 2000, blown glass, 20"H x 16"W x 22"D. Photo by Rob Vinnedge. This image also appears on page 1.

PAGES 2-3 ARTWORK: Fritz Dreisbach, *Wildly Waving Antique Blue Lilac Mongo Compote with Optic Ribs and Cast Base,* blown glass with latticino, 15"H x 32"W x 22"D. Photo by Roger Schreiber.

THIS PAGE: Jeremy R. Cline, *Birds Of Paradise,* blown glass, 34-38"H x 7-8"W x 3-4"D. Photo by Latchezar Boyadjiev.

GUILD Publishing is an imprint of Ashford.com, the Internet's leading retailer of personal and home décor accessories, including fine art and fine craft.

TABLE OF CONTENTS

Introduction
7

Contemporary Glass
A Historical Overview
9

European Influence
17

Blowing
The Vessel & Beyond
31

Hot – Warm – Cold
51

Artist – Designer – Maker
75

Narrative in Glass
87

Glass as Sculpture
109

Contributing Artists
127

Acknowledgements
128

INTRODUCTION

Photo by Tom Mills

Fire, form and light; three unique aspects of glass that merge in no other art medium. This enigmatic material captures the imagination. Often artists come to use it out of curiosity and are caught under its spell. Is it the risk of working directly with the hot molten glass, or the immediacy of the process that keeps the artist coming back? Is it the ability to create an endless variety of forms? Or is it the chance to sculpt with light that holds their attention and commitment to this growing art field?

Whatever the hook, glass grabs those who are exposed to it and doesn't let go. From artists and collectors to students and museum curators alike, glass has received unparalleled attention and more devotion than any other contemporary art medium. Once thought to distract from the meaning of the work, the inherent beauty of glass is now accepted as one of its chief merits.

As a gallery whose focus is on contemporary craft media, del Mano has been involved with glass from our very beginning. We have been privileged to exhibit many of the most recognized artists early in their careers, and play a part in the development of this exciting art form. This book presents a representative sampling of the wide range of work being done in the field — to whet your appetite, and perhaps to dazzle you with the light.

Ray Leier, Jan Peters, Kevin Wallace

OPPOSITE: Harvey K. Littleton, *Blue, Lemon, Ruby Mobile Arc*, 1990, barium/potash glass with multiple cased overlays of Kugler colors, 12¾"H x 13½"W x 2¾"D. Littleton says, "As in all art, most of my decisions are made at the time of creation, in the heat of the moment at the furnace. The shapes are finally fully realized after cutting and polishing and in studying their relationship to one another and the space they define."

ABOVE: Mark Peiser, *Compulsion*, 1997, cast glass, 13½"H x 17½"W x 7¾"D. Winner of a Tiffany Foundation grant and a National Endowment for the Arts Fellowship, Mark Peiser has been teaching since 1969, with positions at the Penland School of Crafts, the Toledo Museum of Art, and Alfred University, among others.

CONTEMPORARY GLASS
A HISTORICAL OVERVIEW

It's hot, really hot. Molten glass, glowing red and with the consistency of honey, clings to the end of the blowpipe. A small furnace blasts white heat. You're standing in an artist's glass studio, feeling the heat and watching the dance of glass.

The artist, sometimes called the *gaffer*, gathers glass from the furnace with a hollow metal blowpipe, shapes the gather, and fuses bits of contrasting glass onto its surface. Alternately blowing air into the almost-liquid mass, spinning and swinging it at the end of the blowpipe, and shaping it with wooden paddles (wet, to keep them from catching on fire), he moves and shapes the glass while assistants follow his pace and try to anticipate his every need. The dance of glass requires that the molten gather be kept at the correct temperature. Every so often, the gaffer or the assistant must get up from the glassmaker's bench and re-heat the object in the *glory hole,* a small furnace especially made for this purpose.

OPPOSITE: Marvin Lipofsky, *Series IGS VI 1997-99 #11,* blown glass, 13"H X 20½"W X 19"D. Once called "the roving ambassador of glass," Marvin Lipofsky has created his glass sculpture throughout Europe and in Australia, Japan, New Zealand, the People's Republic of China, the former Soviet Union and Taiwan, as well as his studio in Berkeley, California. Lipofsky shares his interest in foreign countries and their cultures with his students at home and abroad. As a founding member and past president of the Glass Art Society, he is a seminal figure in international communication among artists.

ABOVE: Erwin Eisch, *Picasso The Clown,* mirrored and painted glass, 18½"H x 9"D. Erwin Eisch was instrumental in redefining glass as a pure art medium. In discussing imagery in glass, he says, "The fundamental tendency in art today is the longing for images. This longing will surely not pass by the glass artists without a trace. If the glass movement is not just to be a motion of handcraft, then it has to move with the spirit of the times, it has to reflect these tendencies."

CHAPTER ONE

Herb Babcock, *Vortex #12*, 2000, cast glass, bronze and stone, 43"H x 23"W x 26"D. Before 1974, Herb Babcock's work was predominantly fabricated in steel. By 1983 he was combining steel and glass into sculptural forms to address social and cultural issues.

Jane Bruce, *Black/Purple Lidded Vessel (Series II)*, 1999, blown, wheel cut and hand finished glass, 6"H x 9½"Dia. Originally schooled in England at the Royal College of Art, London, Jane Bruce was instrumental in the growth of the New York Experimental Glass Workshop, first as artist-in-residence, and then as education director.

Paul Marioni, *Tattoo'd Man*, 1997, glass and enamels, 25"H x 25"W. Marioni has a surrealist's vision and works with the medium of glass because of its ability to capture and manipulate light. He says, "Glass is very challenging, with limitations of color, detail and size. I love problem-solving, finding a way to put my vision into reality. While my techniques are often inventive, they are only in service of the image."

When the bubble of glass reaches the desired size, the team attaches a second solid rod, the *pontil,* to the opposite side of the bubble from the blowpipe and cracks the glass off of the blowpipe. The hole left by the blowpipe is opened and manipulated to create the mouth or neck of the piece. Finally, satisfied that the work is complete, the artist cracks the piece off from the pontil and places it into an annealing oven, where it will cool slowly to room temperature and the stresses that have built up in the glass will be gently relieved.

The raw materials that go into the making of glass are called the *batch* and include *formers* — usually silica, from sand or crushed pebbles; *fluxes* such as soda ash, to lower the melting point of the batch; and *stabilizers* like limestone, to strengthen the glass. Metal oxides provide color. The batch is heated in furnaces to approximately 2300 degrees Fahrenheit. Through this magical process, artists turn sand into glorious objects and intriguing sculptures defined by light, color and form.

The earliest known examples of glass vessels are about 3,500 years old and were made in ancient Mesopotamia and Egypt. *Core-formed* pieces were created by individual artisans who heated the glass with a flame and wrapped it around a core that was later removed; it was a slow and laborious process. The blowpipe, first used around 50 BC, revolutionized the making of glass objects by greatly speeding up the process. As methods of working and annealing glass improved, shops and factories were established. By the time of ancient Rome, larger furnaces and efficient molding techniques allowed for mass production.

Prior to the 1960s, hot glass was created almost exclusively in factories; artists had little involvement in the actual process. Instead, they acted as designers and relied on skilled glassworkers to realize their designs. Examples of such factories include the Tiffany glassworks in the United States and the

HISTORICAL OVERVIEW

Daum glassworks in France. A few artists had started using glass in small studio settings, but the techniques did not involve the extreme heat required for blowing glass. Instead, glass was slumped and fused, usually in sheets, by using modified ceramics kilns. It took a unique convergence of elements to produce the watershed events that would give a new definition to the term "studio glass."

Born in a gardener's shed during a workshop at the Toledo Museum of Art in Toledo, Ohio, in 1962, the contemporary studio glass movement began with experimentation and invention, and has grown into an exciting and challenging medium of artistic expression. Harvey Littleton (b.1922), recognized as the movement's founder, is the son of the former Director of Research at Corning Glass Works (now Corning Inc.). As a child, he was surrounded — and fascinated — by glass. Choosing a career in the arts, he initially studied sculpture and industrial design, and later became a ceramist. While teaching ceramics at the University of Wisconsin-Madison in the 1950s, Littleton dreamed of finding a way for an individual artist to work directly with glass outside of the factory setting. He later traveled to Italy to visit the glass factories and small glasshouses of Murano, where he saw the possibility of making a hot glass studio a reality.

In March 1962, together with the Toledo Museum of Art (under the auspices of Otto Wittmann), Littleton held his first workshop in the now-famous gardener's shed — actually, the building where the museum kept its lawnmowers — for artists interested in experimenting with glass. Dominick Labino (b.1910), an acquaintance of Littleton's, attended this workshop and helped build a small furnace. Labino, a glass scientist and engineer for the Johns Manville Corporation, offered both materials and advice. Following a failed attempt to melt glass from raw materials, the group found the answer by melting a kind of glass marbles developed by Labino for

Gianni Toso, *Channuka With Rabbis in Garden,* 1999, lampworked glass, 19"H x 14"W x 8"D. Toso was one of the first Italian masters to come to the United States to teach. He encouraged his American students to find context for their work. Tradition and history play an important role in his colorful and energetic creations.

Richard Marquis, *Blue Boy's Mamie,* blown and cast glass, 21½"H x 23"W x 13"D. Richard Marquis studied ceramics and then glass at the University of California, Berkeley. He went on to teach there and at the University of California, Los Angeles, where he was the head of the glass department. As a guest designer at the Venini factory in Italy, he learned the difficult technical skills that gave him a vocabulary for his work.

CHAPTER ONE

Henry Halem, *Elijah's Cups,* 1999, blown vessels with scavo coating in glass box, reverse glass drawings and shards, 23½"H x 26½"W x 6½"D. The consummate educator, Henry Halem was professor and director of glass studies at Kent State University, Ohio, for over 30 years. His work and his teaching have had a major impact on the field. "I try to define my art by content and not by material," he says. "Art is about ideas, ideas that spring from observation, the persistence of memory and experience."

Robert Kehlmann, *Drake's Estero,* 1991, sandblasted glass, mixed-media on board, 7⅝"H x 14⅛"W. Robert Kehlmann describes himself as "self-taught in art. I was formally trained in aesthetics and critical analysis during graduate studies in English literature. When I began making art in 1971, I quickly became aware of the similarities in the experiences of reading poems and looking at paintings."

William Carlson, *Quadrant Construct,* 1999, glass and steel, 28"H x 23"W x 13"D. As head of the glass program at the University of Illinois, Champaign, William Carlson has had a profound influence on artists working in glass today. He says of his own work, "Even though my work uses mixed materials and is decisively constructivist in its aesthetic origins, I try to exploit fluidity and atmosphere created by opacity, translucency and transparency."

making fiberglass. This initial workshop, followed by a second in June of the same year, gave birth to the contemporary glass studio movement.

In 1963, Littleton introduced the first hot glass classes into the curriculum of the University of Wisconsin art department, and by doing so elevated the use of glass to a higher level of acceptance in the art world. Early students came to glass from many disciplines. The influence of the glass program at UW-Madison was to stretch over many years and spread to universities and colleges across the country. Marvin Lipofsky (b.1938), who had a degree in industrial design, studied with Littleton and went on to start glass programs at the University of California at Berkeley, and the California College of Arts and Crafts in Oakland. Other Littleton students also initiated glass programs: Robert Fritz (b.1920) at San Jose State College; Fred Marcus (b.1941) at the University of Illinois, at Illinois State University and finally at UCLA; and Kent Ipsen (b.1933) at the Art Institute of Chicago. In 1967, Dale Chihuly (b.1941), who had come to Littleton's program with a degree in Interior Design and Architecture, graduated and went on to found the Rhode Island School of Design glass program.

In addition to these formal programs, the word was being spread though workshops and symposiums. Some students left the university setting to build their own private glass studios; one of the first in the United States was founded by Pat Esch, among the first of many women who have made glass their medium of choice.

Following the June 1962 workshop, Littleton returned to Europe where, in the Black Forest region of Germany, he found an artist making glass sculpture. Erwin Eisch (b.1927) had little reverence for traditional glass approaches; instead, he was experimenting with the potential glass offers as a

HISTORICAL OVERVIEW

sculptural medium. At the First World Congress of Craftsmen, held at Columbia University in New York City in 1964, Harvey Littleton held a hot-glass workshop, and Erwin Eisch attended. The friendship that developed between these two artists marked the beginning of an ongoing relationship among American and European glass artists. At the end of the event, Eisch said, "The little furnace is the future."

The late 1960s and the 1970s were a time of enormous growth in the glass world. Teachers and students alike traveled to Europe and were exposed both to the technical virtuosity of European glass artists and to their use of glass as a pure sculptural medium. Many visited Murano, Italy. Here glassmaking techniques were well guarded family secrets, but some factories, like Venini, were willing to host visiting students. Others travelers went to Czechoslovakia (now the Czech Republic), Finland and Germany, where artistic expression defined the technique. Artists from around the world came to the United States to teach and lead workshops. This international interchange was welcomed in the classrooms and studios of the new "glass artists."

The first decade of studio-made glass in the United States followed the lead of contemporary ceramics in design and was strongly influenced by technical considerations; each rediscovered technique expanded the vocabulary of the glass artists. Although the initial focus was largely on creating vessel forms, the influence of Eisch and Littleton also led artists to create sculpture early in the field's development. Many museums (including Toledo and the Corning Museum of Glass) already held collections of historical glass objects; it was a natural progression for them to expand their collections to include the new work in glass.

Like artists working in other media, glass artists were influenced by contemporary art trends: abstract expressionism,

Sydney Cash, *Suspended Diamond Bowl*, 1996, slumped glass bowl over wire, 7⅞"H x 14½"W x 7⅛"D. Sydney Cash's "artist's prayer" is a statement about his work. It says, in part, "May my work respond to the turnings of the seasons and the yearnings of my heart. May I see deeply into the materials I use and hear their inner voices. May I be at one with the process of making, so that each step is its own fulfillment."

Dan Dailey, *Harlequins*, two-part blown glass vase, 18"H x 13½"W x 8"D. As an instructor at the Rhode Island School of Design, and the founder/director of the glass program at the Massachusetts College of Art, Boston, Dan Dailey brought a refined design aesthetic to contemporary glass. His own work reflects his varied interests, including the use of metals with glass.

Vernon Brejcha, *Desert Desserts*, blown glass, tallest form 17½"H x 3½"W. Vernon Brejcha says, "Growing up on a small Kansas farm, I found glass the perfect medium for telling stories about the prairie. Its fluid transparency allows the insertion of atmosphere. As molten glass is gathered from the furnace, I feel I'm still creating part of a harvest important to life, not technical art about art, but statements about passion and nature."

13

CHAPTER ONE

Lino Tagliapietra, *Hopi*, blown glass, 31"H x 8"W x 8"D. Considered by many to be one of the most accomplished master glass blowers in the world, Lino Tagliapietra brought more than technical skill when he came to the United States to teach and work. He also brought a generosity of spirit that gained him enormous respect among the American glass artists.

Photo by Douglas Schaible

Tom McGlauchlin, *Homage To Kandinsky*, 1995, blown glass with crushed glass, 14"H x 10"W x 4"D. Tom McGlauchlin says, "In recent years I have been studying the work of Wassily Kandinsky, trying to understand his wonderful sense of color. In this piece I have combined my love for the music of Thelonius Monk with an attempt to capture the color and form of Kandinsky."

Photo by Tom McGlauchlin

Joel Philip Myers, *Color Study #1*, 1997, blown glass, 14½"H x 5½"D. After receiving an MFA degree in ceramics from Alfred University, Joel Philip Myers became the director of design at Blenko Glass Company in West Virginia. In 1970, he became a professor of art at Illinois State University, Normal. He says of his own work, "My love for pure color connects perfectly with these floral images; I am a romantic, interested in observing and representing the beauty of the natural world in my own particular abstract idiom, aided, as I am, by the magic of light and glass."

Photo by Rob Whitworth

pop art, California funk, psychedelic, and many other art styles were expressed in glass. It was a time of social and political re-evaluation, when a life devoted to the making of art was a conscious lifestyle choice, and an alternative to the conventionalism and materialism of the 1950s.

The 1970s also saw the growth of a new kind of art gallery, one devoted to work in traditional craft media. These galleries represented the new glass artists along with those experimenting in the other studio arts: ceramics, wood, fiber and metal. As the field grew, galleries opened that were devoted entirely to glass. Glass artists gained recognition through one-person exhibitions, catalogs, and magazine and newspaper coverage. Two magazines documenting this emerging field are *Neues Glas*, published in Germany, and *Glass* magazine, published in the United States.

Because of this burgeoning exposure, the mystery and magic of glass influenced artists all over the United States and the world. In 1971, the Glass Art Society was organized and held its first meeting at Penland School for Crafts in North Carolina; "GAS" soon became a forum for education and communication among artists and teachers. In the same year, a seasonal school devoted entirely to glass was opened north of Seattle, Washington. Co-founded by Dale Chihuly, John Hauberg and Anne Gould Hauberg, the Pilchuck Glass School was dedicated to the development of glass as an art form. Its summer programs brought together an international array of artists and students. Those already established in the glass field were joined by artists from such diverse disciplines as printmaking, painting, sculpture, metalworking and stone carving. Eventually other glass centers opened, including the New York Experimental Glass Workshop (now Urban Glass) in Brooklyn, New York, and the Creative Glass Center of America at the Wheaton Village Glass factory in southern New Jersey.

HISTORICAL OVERVIEW

Today, there are hundreds of contemporary glass studios across the country and around the world. Some exist to create one-of-a-kind works of art, while others produce functional and decorative work ranging from goblets to vases to paperweights. A number of production glass studios follow in the footsteps of workshops established by Louis Tiffany, Emile Gallé, René Lalique and Steuben: factories noted for their production of a wide range of art glass objects designed by a lead artist. These studio artists have revived not only the technical and aesthetic approaches used by the earlier companies, but also strategies regarding the creation of collectable perfume bottles, paperweights and vases.

The story of contemporary glass is one of evolving circles. With each rediscovered technique, the field was redefined and expanded. At first the individual artist's studio was the standard. It was considered important that the work came from the artist's own hand as well as his intellect. Soon artists realized that they could be more productive and more efficient if they worked with assistants; thus small teams of glassmakers became responsible for the final outcome. Influenced by European artists who had been trained as "designers," and by Dale Chihuly, who took on the role of designer by necessity, after a car accident left him unable to blow his own creations, the idea of the artist as designer became acceptable in small glass studios.

Having freed themselves from the factory setting, artists are again reaching out beyond the work of their own hands and using their talents and the talents of others to create in this dazzling medium. In the last few decades contemporary glass has seen unprecedented technical and aesthetic growth. Historical methods, approaches from Europe, and concepts from contemporary art have combined to create a bold new art form. Today, in studios across the country, artists are creating extraordinary visions in glass, from brilliant functional objects to major provocative works of art.

Michael Glancy, *Infinite Obsessions*, 1999, deeply engraved blown glass, deeply engraved industrial plate glass, and copper, 13"H x 18"W x18"D. Trained at the Rhode Island School of Design and later an instructor there, Michael Glancy was among the first to mix metal and glass. He challenged the preconceptions of blown glass and opened the door to unlimited possibilities.

Gene H. Koss, *Watts Tower Climb*, cast glass, steel and neon, 13'H x 8'W x 14'D. Founder and head of the glass program at Tulane University, Gene Koss uses equipment he developed to manipulate the glass in his monumental sculpture. He says, "I have developed techniques to transform my memories of the mechanized Wisconsin farm of my youth into foundry-based glass sculpture."

EUROPEAN INFLUENCE

The contemporary glass movement has been driven from the start by the interchange of ideas and techniques between America and Europe. As early as 1972, an international group of educators and designers came together at the Museum Bellerive in Zurich, Switzerland; after two weeks of working together they made a commitment to exchange information and visits in an effort to promote the acceptance of glass as an art form. Many American glass artists traveled to glass factories in Italy, Czechoslovakia, England and Scandinavia to expand their skills and technical expertise. They studied with the masters and then returned to the United States to teach each other. They also invited European artists to participate in symposiums, university classes, summer programs and conferences in the United States.

Venetian glass masters, in particular, were instrumental in the rise of the "glass art" movement in the United States. They brought the refined technical expertise that had been developed in Italy over hundreds of years.

With the exuberance and energy that they brought to their work, the Americans in turn inspired European designer/artists to view their roles in a new light, and to venture outside of the factory setting and into the realm of artist/maker.

Infected by American independence, European — and later Australian and Japanese — artists have come into their own to exhibit and sell their work. What began as an interchange of ideas and methods has grown into a global phenomenon, as the magic of glass continues to capture the imagination of artists around the world.

Lino Tagliapietra, *Melon Vase*, blown glass, 12½"H x 10"W x 10"D.

Ralph Mossman

CHAPTER TWO

UPPER LEFT
TITLE: Digital Tie-Dye #25
DESCRIPTION: Blown glass
DIMENSIONS: 16"H x 7"Dia.

UPPER RIGHT
TITLE: Digital Tie-Dye #3
DESCRIPTION: Blown glass
DIMENSIONS: 14"H x 7"Dia.

LOWER LEFT
TITLE: Digital Tie-Dye #5
DESCRIPTION: Blown glass
DIMENSIONS: 12"H x 5"W x 7"D

LOWER RIGHT
TITLE: Branches & Roots
DESCRIPTION: Blown glass
DIMENSIONS: 12"H x 7"Dia.

"The *Digital Vase* series is inspired by my interest in digital imaging. I am also challenged by the abstract expressionist quest to create the illusion of depth in a two-dimensional surface, coupled with the reality of the thickness in the wall of the vessel."

— Ralph Mossman

Photos by Jake Schweers

EUROPEAN INFLUENCE

Harry Stuart

TITLE: Transparent Vase
DESCRIPTION: Blown glass
DIMENSIONS: 16"H x 9"Dia.

"The desire to explore the interplay of color and light was brought together for me with my discovery of glass. My work involves producing objects that deal with color interaction: transparency/opacity, vibration/harmony, value, contrast, spatial definition, recession/projection, saturation, discord."

— Harry Stuart

Kyohei Fujita

CHAPTER TWO

TITLE: Red & White Plum Blossoms, 1992
DESCRIPTION: Mold-blown glass in two parts, with gold, silver and platinum foils, sterling silver fittings
DIMENSIONS: 9⁷⁄₈"H x 7¹⁄₂"Dia.

"I will never forget how excited I was when I finally succeeded in producing a box that matched my mental image exactly. Once, at a lecture in Copenhagen, someone asked me, 'What is your decorated round box used for?' and I answered, 'To hold the dreams of the person who bought it.'"

— Kyohei Fujita

EUROPEAN INFLUENCE

Lucio Bubacco

TITLE: Fisher Devils, 1999
DESCRIPTION: Lampworked and blown Murano glass
DIMENSIONS: 20½"H x 15"W x 14⅛"D

The son of a very important glass master in Murano, Lucio Bubacco began working with glass when he was a child. After studying anatomical drawing, his work became focused on the movement of the figure, captured in glass.

Photo by Norbert Heyl

21

Takeshi Tsujino

CHAPTER TWO

TITLE: Window Series #14, 1997
DESCRIPTION: Blown glass with enamel
DIMENSIONS: 11¾"H x 8"W x 5½"D

TITLE: Window Series #12, 1998
DESCRIPTION: Blown glass with enamel
DIMENSIONS: 17"H x 11¾"W x 16¼"D

EUROPEAN INFLUENCE

Bertil Vallien

TITLE: Finding X
DESCRIPTION: Cast glass
DIMENSIONS: 15"H x 14"W x 14"D

"Glass eats light. To capture traces that can't be removed. Fire and ice. Those two states of catastrophe are an inspiration. To ladle from a volcano and see the transformation to cold ice. No other material offers that journey."

— Bertil Vallien

Sam Stang

CHAPTER TWO

TITLE: Murrini Cone Bowls
DESCRIPTION: Blown glass
DIMENSIONS: 16 1/2"Dia.

"My greatest influences have been 20th century Venetian and Scandinavian glass. I use traditional European glassblowing techniques to make these pieces and my work is entirely produced hot at the furnace, using no glue."

— Sam Stang

EUROPEAN INFLUENCE

Peter Greenwood

TITLE: Ruby Lace Set
DESCRIPTION: Blown glass
DIMENSIONS: Plate: 20"Dia. Bowls: 16"Dia.

"I draw my inspiration from the great masters of Murano, Italy. I have traveled to some of the glass centers of Europe: Venice, Italy; Orrefor, Sweden; and Haracof, Czechoslovakia. This has given me a perspective on how glass is worked internationally."

— Peter Greenwood

CHAPTER TWO

Janusz Walentynowicz

Photo by Ann Charback

TITLE: Her Garden
DESCRIPTION: Kiln cast glass, welded steel, oil paint
DIMENSIONS: 30"H x 32½"W

Painting on the back as well as the front of his pieces, in a process he has developed over the years, Janusz Walentynowicz creates the effect of three-dimensional form, inviting the viewer to look beyond the surface.

EUROPEAN INFLUENCE

Jaroslava Brychtová • Stanislav Libenský

TITLE: Space
DESCRIPTION: Glass
DIMENSIONS: 11½"H x 12"W x 3"D

Working in Czechoslovakia (now the Czech Republic) during the 1950s and 1960s, Stanislav Libenský and Jaroslava Brychtová made an indelible impression on American glass artists at the 1967 Montreal Expo with their monumental glass sculpture.

Dimitri Michaelides

CHAPTER TWO

TITLE: Bird Vases
DESCRIPTION: Blown glass
DIMENSIONS: Tallest 28"H

"The *Bird* series began in 1990 as a collaboration between David Levi and myself, and with a fellowship award from the Creative Glass Center of America. Works in the series have changed with time, but still concern themselves with the history of the vessel — relationships of color, form, gesture, posture."

— Dimitri Michaelides

EUROPEAN INFLUENCE

Dante Marioni

TITLE: Chartreuse With
Orange Trio, 1999
DESCRIPTION: Blown glass
DIMENSIONS: 38"H, 20"H, 40"H

Although Dante Marioni
describes his work as "the art of
glassblowing rather than the
blowing of glass art," many have
described his elegant colorful
vessels as minimalist art.

BLOWING THE VESSEL & BEYOND

The history of glass is largely the history of the glass vessel. For 2,000 years, glass has been blown to create containers, thereby giving it deep roots as a functional medium. Like ceramics, basketry, and even turned wood, the very process of glassblowing naturally lends itself to the creation of the vessel form. Hot glass is formed on the blowpipe, as the gaffer uses centrifugal force (by rotating the blowpipe) to fight the tendency of the molten glass to droop under the pull of gravity. Human breath, introduced through the blowpipe, produces a bubble, and thus a vessel begins.

Handblown glass has a rich heritage that encompasses many centuries and cultures. Because today's artists can combine ancient methods with new ideas and aesthetics, blowing remains the most prominent glass technique, and is the foundation of some of the most striking examples of contemporary glass. As in the other classic craft disciplines, the vessel in glass has evolved beyond function. It has become the canvas on which the artist can express ideas about balance, space, color and light. It can become a metaphorical container, representing the body as the container of the soul, and the mind as the container of ideas.

The early years of experimentation with equipment and techniques have paid off now by allowing artists to fully realize the many possibilities glass blowing has to offer. The blown form is frequently used today as a jumping off point in conjunction with other glass-making methods and even other materials such as metal, wood and stone. The furnace and hot glass have become effective tools, allowing contemporary artists to create their precise visions.

Photo by John Littleton

John Littleton and Kate Vogel, *Acro Bag*, acid-etched blown glass, 18"H x 8¾"W x 8"D. Littleton and Vogel describe their partnership: "After twenty-one years of collaboration, the give and take of ideas has become as natural as breathing. Ideas evolve from dialogue relating to feelings, thoughts, dreams and ordinary experiences. The work evolves and grows as we journey through life. Through discussion, we find a common vision that is the seed for a piece."

David Schwarz

CHAPTER THREE

TITLE: 6-11-99
DESCRIPTION: Glass
DIMENSIONS: 10"Dia.

"I draw structures that read 'mass,' and place them in an environment devoid of gravity. Through the use of optics, I give the structures life and the freedom to move about my space. I want my work to be visually explored."

— David Schwarz

BLOWING: THE VESSEL & BEYOND

Richard Ritter

TITLE: Forescence Series #6, 2000
DESCRIPTION: Floral murrini glass vessel
DIMENSIONS: 4½"H x 11"Dia.

"All around us exists a natural world full of pattern and color. For many years, I have explored the fragile nature of glass utilizing murrini and lattacino to create visual expression. Each of these elements are suspended, their imagery caught in time, trapped beneath the surface, becoming my vocabulary and my narration."

— Richard Ritter

Photos by John Littleton

33

Anthony Corradetti

CHAPTER THREE

TITLE: Pods #3
DESCRIPTION: Blown and painted glass
DIMENSIONS: 16"H x 16"Dia.

"What fascinates me about glass is its unique relationship to light, which gives it a free-floating quality. I want my pieces to have a handled quality and to be a record of my involvement with them. Technical virtuosity and flawless execution are not my concern, but rather the marriage of form and color with spontaneous and expressive energy."

— Anthony Corradetti

BLOWING: THE VESSEL & BEYOND

Robert Levin

TITLE: Pear and Chili Pepper Goblets, 1999
DESCRIPTION: Sandblasted and acid etched glass
DIMENSIONS: 12"H, 8"H

"My frosted blown glass pieces deal with balance, gesture and fluidity. The approaches I use are eclectic and personal at the same time — sort of a blend of Late Venetian and Early Neurotic."

— Robert Levin

Harvey K. Littleton

CHAPTER THREE

TITLE: Ruby Spray, 1990
DESCRIPTION: 14 parts, barium/potash glass with multiple cased overlays of Kugler colors
DIMENSIONS: 17 1/4"H x 30"W x 30"D

Harvey Littleton is a seminal figure in the contemporary glass world. It was his vision and guidance that brought glass into the universities as an art medium.

BLOWING: THE VESSEL & BEYOND

Marvin Lipofsky

Photo by M. Lee Fatherree

TITLE: Rit Group 1996-99 #2
DESCRIPTION: Blown glass
DIMENSIONS: 8½"H x 12½"W x 9½"D and 9½"H x 11"W x 8"D

Marvin Lipofsky's sensual, organic sculptures take the viewer on an exploration of interior versus exterior and positive versus negative through their undulating curves and changing textures.

Richard Royal

CHAPTER THREE

TITLE: Nota Bene
DESCRIPTION: Welded copper with blown glass
DIMENSIONS: 42"H x 9"W x 8"D

"Much of my work relies on a great deal of heat, gravity and centrifugal force to develop the final form. Although I rely on symmetry during the process, I'm much more interested in an asymmetrical form for the finished product."

— Richard Royal

Photo by: Robert Vinnedge

BLOWING: THE VESSEL & BEYOND

Josh Simpson

TITLE: Tektite, 1994
DESCRIPTION: Meteorite glass
DIMENSIONS: 5"H x 11"W x 9"D

"My motivation comes directly from the material itself; glass is such an incredibly beautiful and impossibly difficult substance to work with. I attempt to coax it; all it wants to do is drip on the floor. Most of my work reflects a compromise between the glass and me; the finished piece is the moment in time when we agree."

— Josh Simpson

Gary Beecham

CHAPTER THREE

TITLE: Primary Nova, 2000
DESCRIPTION: Handblown, fused glass in a stainless steel armature
DIMENSIONS: 18"H x 16½"W x 13½"Dia.

"I approach glass as a three-dimensional, transparent canvas that I can form in any desired shape. For most of my working career, I have used the vessel as a sculptural form — with the interiors serving to contain light, color and reflections — rather than as physical objects. In this series, the designs are no longer gemlike, but transparent paintings held in stainless steel."

— Gary Beecham

Photo by John Littleton

BLOWING: THE VESSEL & BEYOND

Stephen Rolfe Powell

LEFT and TOP
TITLE: Purple Zippy Mania, 2000
DESCRIPTION: Blown glass
DIMENSIONS: 42¼"H x 22"W x 12"D
ASSISTED BY: Brent Sommerhauser, Chris Bohach,
D.H. McNabb and Paul Hugues (both works shown)

ABOVE
TITLE: Purple Aloof Cleavage (detail)
DESCRIPTION: Blown glass
DIMENSIONS: 43⅝"H x 22½"W x 11½"D

"My work is mostly about color; I hope that the color combinations are unique and that they trigger emotive reactions. The shapes of my pieces are influenced by the gestures and postures of the human figure. A final element of my work is the texture created by thousands of colored beads applied to the surface. I encourage viewers to touch my pieces."

— Stephen Rolfe Powell

Photos by Stephen Rolfe Powell

Ann Troutner

CHAPTER THREE

TITLE: Electric Tripeds, 1987 (seven pieces)
DESCRIPTION: Blown glass
DIMENSIONS: 19"H x 27"W x 6"D

"Fluidity of motion is the prevalent intent throughout my career. The gesture captured and stilled must be interpreted intuitively, the same as reading body language."

— Ann Troutner

BLOWING: THE VESSEL & BEYOND

Dan Dailey

TITLE: Dancing Weasels
DESCRIPTION: Three-part blown vase, sandblasted, acid polished, blown base, fabricated patina and gold-plated bronze figures
DIMENSIONS: 56"H x 18"W x 20"D

"What is it about the awesome beauty of nature that draws a person to stop and watch a sunset or makes a particular individual so beautiful or handsome? These are aesthetic qualities more than anything else, and that is what attracts us. Can an artist contrive to attract by creating a thing of beauty? Very likely, yes. Is art created which is devoid of intellectual content? Very likely, yes."

— Dan Dailey

Photos by Bill Truslow

Thomas Philabaum

CHAPTER THREE

Photo by Steven Meckler

TITLE: Ancient Vessel 2000
DESCRIPTION: Handblown glass, scavo surface
DIMENSIONS: 16"H x 10"W x 7"D

Like many glass artists, Tom Philabaum began by working in ceramics. Besides creating his own glass sculpture, he is an active member of the glass community and operates a gallery devoted to the exhibition of glass in Tucson, Arizona.

BLOWING: THE VESSEL & BEYOND

Laura Donefer

Photo by Steven Wild

ARTIST: Laura Donefer
TITLE: Bonne Chance Witch Pot
DESCRIPTION: Blown and sandblasted glass, mixed media
DIMENSIONS: 18"H x 20"W x 10"D

"Liquid heat is my main medium. Working with molten glass is like dancing the magma right out of the earth. It is hot and it is dangerous, and sometimes it feels like you are making love with the very essence of creation. For me, glass is a metaphor for life. It can be totally transparent and reveal what is inside, or opaque to hide, or translucent and mysterious, giving mere glimpses of what might be there."

— Laura Donefer

Flo Perkins

CHAPTER THREE

ABOVE
TITLE: Lino's Cactus, 1997
DESCRIPTION: Blown glass
DIMENSIONS: 6"H x 4"W x 4"D

RIGHT
TITLE: Tierra del Fuego, 1999
DESCRIPTION: Blown glass
DIMENSIONS: 17"H x 17"W x 17"D

"My work reflects in-depth investigations of the relationship between blown glass and botanical forms. Through the study of cacti, I began to realize how flowers bud, bloom and collapse, and how that relates directly to the technical process of blowing glass: the bubble, the opening and the folding."

— Flo Perkins

Photos by Addison Doty

BLOWING: THE VESSEL & BEYOND

John Leighton

TITLE: Iris Rose With Peach Interior Grouping, 1999
DESCRIPTION: Blown glass
DIMENSIONS: Large bowl: 24"L
ASSISTED BY: Joe Cariati and Tom Blank

"I'm attracted to forms and colors that are familiar, yet strange; accessible without losing their mystery; perhaps even a bit unsettling. Without denying their references, these forms refuse to be a specific plant, seed or creature."

— John Leighton

Michael Schunke

CHAPTER THREE

TITLE: Bottle and Silhouette, 1998
DESCRIPTION: Blown glass
DIMENSIONS: 30"H x 10½"Dia.

"*Bottle and Silhouette* is part of a continuing series of pieces in which I am trying to explore the mystery of the interior and our natural curiosity for 'what is inside.' This piece also emphasizes my belief that art can have a function, which is to remind us that objects we see every day are beautiful and there are struggles that people go through every day which are extraordinarily difficult."

— Michael Schunke

BLOWING: THE VESSEL & BEYOND

Sonja Blomdahl • Gary Genetti

ARTIST: Sonja Blomdahl
TITLE: Blue Pink/Gold Blue (B7199)
DESCRIPTION: Blown glass
DIMENSIONS: 15½"H x 11"Dia.

"Throughout the 3,000 years of glassblowing history, the vast majority of objects produced have been vessels. For me personally, there is still much to explore. The relationship between form, color, proportion and process still excites me."

— Sonja Blomdahl

ARTIST: Gary Genetti
TITLE: Incalmo Covered Jar, 1996
DESCRIPTION: Blown and sandblast-etched glass
DIMENSIONS: 12"H x 9"W x 9"Dia.

"I use the natural beauty of glass as an environment for my precisely engraved and etched drawings. Found in practically every culture, both ancient and modern, this universality of decorative pattern has formed a context for the evolution of my personal and unique aesthetic statement."

— Gary Genetti

HOT – WARM – COLD

Prior to the 1960s and 1970s, before "hot blown glass" became synonymous with contemporary studio glass, artists worked with glass in small studios using techniques that did not require the intense heat of a furnace. During the 1970s and 1980s, these cool — i.e., room temperature — glass techniques (including sandblasting, acid etching, constructing, and painting) and warm glass techniques (flameworking, slumping, casting and fusing) took a back seat to the hot technique of glassblowing, but they never disappeared entirely. In the 1990s, a growing number of artists turned to "cooler" methods to express their visions. Each technique presents its own set of challenges and range of possibilities.

Flameworking (also called "lampworking" and "torchworking") is a technique that has ancient, if somewhat humble, roots. It refers to techniques that utilize a small burner or torch to heat, melt and form glass. Rods or tubes of glass are melted and worked while held over the flame or torch at a bench or table. Used alone, the control afforded by this method of working glass allows the construction of intricate figures and delicate structures. Used in conjunction with blowing or casting, it makes possible the addition of fine details and thus the creation of a more complex vessel or sculpture.

With fusing and slumping, pieces of (usually flat or plate) glass are formed into a single object in a kiln. Casting is usually accomplished by pouring or blowing hot glass into a mold, or by melting powdered or crushed glass. All manner of objects — from metal to other glass components — can be placed within the molds so that they appear to be encapsulated within the final cast glass object, enhancing its depth and adding a touch of mystery.

Beginning with an already finished blown or cast glass object, or with commercially made glass, many artists work directly on the surface using sandblasting, etching, engraving and painting techniques. By cutting, polishing and gluing solid sheets of glass together, glass sculptures can be constructed that transmit and reflect light in intriguing ways.

Steven Weinberg, *Tiverton Bay Buoy*, 2000, cobalt crystal buoy, "spray-metalized," rusted steel, 15"H x 5"Dia. Weinberg says, "My buoy forms contrast with rough, textured surfaces to show the wear and violence of the sea, the shoreline and the fisherman himself. Both boat and buoy exemplify man's ongoing struggle to harness nature and to make art. Thus, I take the boat and the buoy, two ancient human creations with symbolic value resonating within, and use them as the basis for a crystal casting."

Photo by Douglas Schaible

Ann Alderson Cabezas

CHAPTER FOUR

TITLE: Oak
DESCRIPTION: Blown, carved and painted glass
DIMENSIONS: 5½"H x 7½"Dia.

"My glass pieces speak of beauty, grace, movement and joy. I have been a dancer since a very young age, and this has been a great influence on how I approach the world."

— Ann Alderson Cabezas

HOT – WARM – COLD

Victor Chiarizia

Photo by Holly Augeri

TITLE: Past Lives With Skullberries, Botanical Series 2000
DESCRIPTION: Flameworked and hot glass
DIMENSIONS: 12"H x 5"W

Victor Chiarizia combines flameworking, hot glass and glass painting in each piece in his *Botanical* series.

53

Mary Ann "Toots" Zynsky

CHAPTER FOUR

TITLE: Luciola Serena
DESCRIPTION: Glass threads, fused and kiln formed
DIMENSIONS: 8"H x 16½"W x 9¾"D

A graduate of the Rhode Island School of Design, Toots Zynsky was the assistant director of the New York Experimental Glass Workshop (now Urban Glass), on the faculty of Parsons School of Design, New York City, and a recipient of a National Endowment for the Arts Fellowship. She is inspired by Italian paintings from the 14th and 15th centuries in her explorations in color.

HOT – WARM – COLD

Robert Carlson

TITLE: Kundalini, 2000
DESCRIPTION: Blown glass, enamel paint, gold and copper leaf
DIMENSIONS: 39"H x 11"W x 9"D

"In great religious folk art there is a sense of power and passion, mystery and awe, which is communicated immediately to the viewer. It is at once direct and simple, though often cloaked in intricacy and detail. I also notice that color plays a critical role in conveying meaning and emotion. These elements tend to leave the viewer empowered and enlivened with a sense of hope in life, and awe at its majesty. It is with these qualities that I strive to imbue my work."

— Robert Carlson

Jeri Goodman

CHAPTER FOUR

TITLE: Bubbles
DESCRIPTION: Fused glass, metal and wood
DIMENSIONS: 31"H x 20"Dia.

"I have chosen the medium of fused glass because of its incredible colors and wonderfully translucent characteristics. I was a ceramic artist for eight years prior to discovering glass, but was unable to satisfy my craving for rich and vibrant colors in my glazes."

— Jeri Goodman

HOT – WARM – COLD

Avery H. Anderson

TITLE: Salmon, 2000
DESCRIPTION: Fused glass
DIMENSIONS: 2"H x 18½"Dia.

TITLE: African Tapestry Series #2, Giraffe, 1999
DESCRIPTION: Fused glass
DIMENSIONS: 2"H x 19"Dia.

TITLE: Raven, 1999
DESCRIPTION: Fused glass
DIMENSIONS: 2"H x 18½"Dia.

"My deep love and respect for animals is the central theme of all my work.
I am especially drawn to the link between the animal world and myth."

— Avery H. Anderson

Photos by Steve Meltzer

57

Phyllis Clarke

CHAPTER FOUR

TITLE: Hyacinth Macaw Urn, 2000
DESCRIPTION: Soft glass
DIMENSIONS: 13"H x 7"W x 3"D

"I believe that all artists who work with diligence and sincerity, and strive to form a unique and intimate relationship with the piece that is in the flame at the moment, will ultimately be able to come to an understanding with themselves and the source of all creativity in the universe."

— Phyllis Clarke

TITLE: Warbler Goblet, 2000
DESCRIPTION: Soft glass
DIMENSIONS: 11½"H x 3½"W x 3½"D

HOT – WARM – COLD

Ellie Burke

TITLE: Butterfly Maiden
DESCRIPTION: Flameworked glass, sandblasting, paint
DIMENSIONS: 10"H x 3"W x 3"D

"I love the immediacy of flameworking. I make components and later assemble them into a larger piece. The best part about the sculptural work is that I get absorbed in the process and forget about time. They become meditations."

— Ellie Burke

Photo by William F. Lemke

59

Paul J. Stankard

CHAPTER FOUR

TITLE: Assemblage: Seeds Pollinating D13, 1997
DESCRIPTION: Lampworked glass
DIMENSIONS: 7½"H x 6¾"W x 2½"D

"I am interested in integrating mysticism with botanical realism and giving the glass organic credibility. Through the work, I reference the continuum of nature by portraying and exploring the mysteries of seeds, fertility and decay."

— Paul J. Stankard

HOT – WARM – COLD

Kari Russell-Pool • Marc Petrovic

Photo by Cathy Carver

TITLE: Peach Teapot
DESCRIPTION: Blown and flameworked glass
DIMENSIONS: 15"H x 17"W x 10"D

"We have always loved the juxtaposition
of the solidity and weight of blown glass with
the delicacy of flameworking. This has been
at the heart of our collaboration."

— Kari Russell-Pool and Marc Petrovic

61

Loy Allen

CHAPTER FOUR

TITLE: Botanicals
DESCRIPTION: Borosilicate glass
DIMENSIONS: 12"H x 6"W x 6"D

"My work is a celebration of the natural world. I've studied and photographed the native flora of the South Dakota hills and plains since 1976. My representational style is intended to affirm the beauty in the detail and design of nature."

— Loy Allen

HOT – WARM – COLD

Shane Fero

Photo by John Littleton

TITLE: Klee Bird, 1999
DESCRIPTION: Flameworked, sandblasted glass
DIMENSIONS: 19"H x 10"W x 8"D

"I try to imbue my work with a metaphysical aspect. I draw on my academic background and my interest in ancient cultures, religion, mythology, psychology and philosophy to impart a more personal, yet universal, presence to my creations on the torch. Finally, a bit of social satire and humor further pushes the envelope."

— Shane Fero

Sidney R. Hutter

CHAPTER FOUR

TITLE: Solid Vase Form # 39 & 41, 1998
DESCRIPTION: Cut plate glass with blue and green dye in the laminations
DIMENSIONS: 17 1/2"H x 9 1/2"W x 9 1/2"D

"Interests in design and architecture, and a background in glassblowing and glass fabricating, form the foundation for a body of work. This work describes or questions issues of form, space, emotion and thought. My work is of a decorative nature and at times may be considered challenging and provocative."

— Sidney R. Hutter

HOT – WARM – COLD

Jay Musler

TITLE: Yellow vs. Orange, 1998
DESCRIPTION: Glass and oil paint
DIMENSIONS: 5"H x 24"Dia.

"I have been able to establish a vocabulary where reality leaves off and creativity begins. The work comes out of a manifestation of thought, as opposed to being a representation of those thoughts."

— Jay Musler

Margaret Oldman

CHAPTER FOUR

TITLE: Spiral Bowl
DESCRIPTION: Slumped, engraved, sand-carved glass
DIMENSIONS: 18"Dia.

"Crystal — hard, brittle and bright — is also soft, gentle, forgiving. It accepts the contrast imposed. It accepts this play of dark and light. It accepts the order of design and the chaos of vision, just as we try to accept our own contrasts, in search for meaning."

— Margaret Oldman

HOT – WARM – COLD

George Bucquet

Photos by Robin Robin

TITLE: Buddha Bowl
DESCRIPTION: Cast glass, copper, metal leaf
DIMENSIONS: 3"H x 24" Dia.

"I enjoy and appreciate many aspects of hot glass, but it's the aesthetic of cast glass that has held my attention for the last 15 years. In the end, it's simple beauty that moves me most, and I feel successful and grateful when it moves others."

— George Bucquet

Gianni Toso

CHAPTER FOUR

TITLE: Visit to Oakland 1976, 1993
DESCRIPTION: Lampworked glass
DIMENSIONS: 17"H x 22"W x 18"D

HOT – WARM – COLD

Douglas James Remschneider

TITLE: Dancing Free, 2000
DESCRIPTION: Lampworked glass
DIMENSIONS: 17"H x 15"W

"I am inspired by the great Venetian masters who created works in glass that boggle the mind. I try to create work that is technical in construction and has true aesthetic value."

— Douglas James Remschneider

Hans-Godo Fräbel

CHAPTER FOUR

TITLE: Flower Goblet -18, Goblet Series No. 128
DESCRIPTION: Clear and colored glass
DIMENSIONS: 22"H

"Glass is worked as a fluid, and I seek to capture this flow at a given, pleasing instant and preserve that instant for contemplation at leisure. I join different flows together as composites which can take on the appearance of everyday objects such as vases and faces."

— Hans-Godo Fräbel

HOT – WARM – COLD

Susan Plum

TITLE: Remedio Rojo, 1999
DESCRIPTION: Blown, cast and flameworked glass
DIMENSIONS: 31"H x 10½"W x 6"D

"For me, glass represents energy, solidified water or spirit. Glass is a medium in which I can make the invisible concrete. The *Remedios* series echoes alchemical jars/healing vessels. The colors and the design of the flameworked stopper speak to healing herbs or the healing heart."

— Susan Plum

Seth Randal

CHAPTER FOUR

TITLE: Grand Double Helix Diatreta, 1993
DESCRIPTION: Pate de Cristal
DIMENSIONS: 16"H x 16"Dia.

"I like to think of my work as based upon and inspired by history, with a 21st century twist. I don't think my work is literal or definite. It is more a collage of color, style and motifs that speaks of ancient people, faraway places, dreams long ago realized and cultures long gone."

— Seth Randal

Photo by Roger Schreiber

HOT – WARM – COLD

Bandhu Scott Dunham

TITLE: Gold Fumed Sphere, 2000
DESCRIPTION: Lampworked glass
DIMENSIONS: 13"H x 11"W x 11"D

"I have enjoyed and pursued lampworking since 1975 because of its immediacy and practicality. The beauty, transparency and fragility of the glass are especially well suited for exploring the themes that interest me."

— Bandhu Scott Dunham

ARTIST – DESIGNER – MAKER

As young artists leave university and college glass programs, they face a question common to graduates in all art media: what to do with their training? They can teach — and many do, even though teaching positions are often difficult to obtain. They can enter the fine art world and become sculptors in glass — also a difficult path, because of the enormous expense of maintaining a hot glass studio outside of a school setting. The growing public interest in well-made art and design has provided a third option for many glass artists: they can pursue a more commercial avenue and produce objects in series designed as unique gifts and unusual collectables.

Many artists find this last option allows them to continue working with glass as an art form and make a living as well. A discerning public, looking for more than white bread functionality, wants a greater personal connection to the objects in their lives. The support of such an audience has allowed the "artist/makers" working alone in the studio to exercise their design skills as in the famous art factories, but with a more hands-on approach. They conceive and execute all the details down to the final prototype, then work with a team of skilled craftsmen to produce it. These production studios frequently hire and train talented young glassblowers as assistants, who, in turn, gain experience and hone their technical skills while continuing to develop their own personal work.

By the very nature of their production, blown glass objects are one-of-a-kind; no two can ever be identical. Within the small production setting, the distinction between "art objects" and "decorative objects" may flow from the intention of the artist/designer in the creation of a piece. When multiples further the realization and exploration of an idea, they are considered a "series" in the art world. When they reproduce a fully realized design, they are considered limited-production collectables.

Josh Simpson, *Megaplanet 10.4.98*, multiple-layer reactive glass, 5¼"Dia. Simpson says, "I like to pack my planets with more information than the naked eye can see. I've always been fascinated by technology. I couldn't begin to build a microchip, but some of my planets probably have as many discrete elements as one."

Photo by Tommy Olof Elder

Steven Maslach

CHAPTER FIVE

TITLE: Dichroic Bowl, Fractured Series
DESCRIPTION: Blown and cast glass laminated with dichroic color filters
DIMENSIONS: 14"H x 12"D

"Glass has been described as a 'container for light'. In my work, I try to fulfill this unique property. Dichroic colors change depending on the angle of the light. I sculpt my glass to bring the colors through the piece, to flow and mix, reflect and transmit."

— Steven Maslach

ARTIST – DESIGNER – MAKER

Stephan J. Cox

Photo by Don Pitlik

TITLE: Celedon Pod, 1999
DESCRIPTION: Hand-carved blown glass
DIMENSIONS: 20"H x 18"W x 18"D

"I personally design and make every piece of glass from my studio. I have been compelled to make things — drawings, painting, etc. — ever since I can remember. The tricky molten material took over my life and since that time I have worked exclusively with hot glass."

Stephan J. Cox

77

Markian Olynyk

CHAPTER FIVE

TITLE: Ocean Toccata
DESCRIPTION: Carved, painted, lacquered, 1/2" tempered glass
DIMENSIONS: Each panel: 78"H x 24"W

"Relevance is the most important aspect of my work. Inspiration is derived from any number of sources, but in the end, the work must be relevant to the building and the people who use it."

— Markian Olynyk

ARTIST – DESIGNER – MAKER

David Van Noppen

TITLE: Incalmo Goblets
DESCRIPTION: Blown glass
DIMENSIONS: 9"H

"In regards to my work, the medium itself is what drives my growth through glass. I am always inspired by the work of other artists, living or dead, and try to put my own spin on it."

— David Van Noppen

79

CHAPTER FIVE

Mariusz Rynkiewicz

TITLE: Damsel, Set, 1995
DESCRIPTION: Blown, sandblasted glass
DIMENSIONS: Tallest piece: 26"H

"Color drives my design. I always have more ideas than I can create. The form begins in my soul, with the ghost of the piece in my mind. Beauty is what is in your mind."

— Mariusz Rynkiewicz

ARTIST – DESIGNER – MAKER

Bruce Pizzichillo • Dari Gordon

TOP LEFT
TITLE: Mosaic Oval Vase
DESCRIPTION: Blown glass
DIMENSIONS: 16"H x 9"Dia.

TOP RIGHT
TITLE: Sea Urchin Bowls
DESCRIPTION: Blown glass
DIMENSIONS: 8"H x 14"Dia.

LOWER LEFT
TITLE: Incalmo Bowl
DESCRIPTION: Blown glass
DIMENSIONS: 10"H x 20"Dia.

LOWER RIGHT
TITLE: Incalmo Vases
DESCRIPTION: Blown glass
DIMENSIONS: 26"H x 9"Dia.

Photos by M. Lee Fatherree

Bernard Katz

CHAPTER FIVE

TITLE: Root Vessel
DESCRIPTION: Blown glass, etched
DIMENSIONS: 10"H

TITLE: Large Root Vase
DESCRIPTION: Blown glass, etched
DIMENSIONS: 22"H

Works in the *Root* series are blown vessels of brilliant color, encased in layers of clear crystal with a final layer of dark colored glass. This final layer is etched away to reveal the botanical images and the underlying colors.

Photos by Jack Ramsdale

ARTIST – DESIGNER – MAKER

Michael Cohn • Thomas P. Kelly

ARTIST: Michael Cohn
TITLE: Athena Bowl and Vase
DESCRIPTION: Blown glass
DIMENSIONS: Bowl: 13"H x 22"Dia., vase: 27"H x 12½"Dia.

"My work is a synthesis between the fluid immediacy of molten glass and the brittle, unforgiving nature of cold-worked glass. I have, to a large degree, approached my work from a purely visual basis in terms of relationships of form and color."

— Michael Cohn

Photo by Charles Frizzell

ARTIST: Thomas P. Kelly
TITLE: Small Seedpod Vase
DESCRIPTION: Blown glass with hot glass additions
DIMENSIONS: 8"H x 8"Dia.

"I found myself blowing glass full time with Thomas S. Buechner III at Vitrix Hot Glass Studio. At Vitrix, visiting artists such as Lino Tagliapietra and Fritz Dreisbach educated and influenced me."

— Thomas P. Kelly

Photo by Frank Borkowski

83

CHAPTER FIVE

Leslie K. Ott • Elizabeth Westerman

TITLE: Box #2
DESCRIPTION: Sheet glass, acrylics
DIMENSIONS: 15"H x 12"W x 12"D

ARTIST – DESIGNER – MAKER

William Glasner

Photo by Dan Neuberger

TITLE: Carved Closed Vessel – Multicolor
DESCRIPTION: Blown glass
DIMENSIONS: 9"H x 10" Dia.

"People have been making decorated vessels for thousands of years. I like being a part of that universal, human tradition. While I try to make distinctive work, the admonition 'make it new' is a call for my own personal attention in each moment of creation."

—William Glasner

sugar

spice

If women can sleep their way to the top, how come they aren't there?

I'm just a person trapped inside a woman's body?

I want to be more than a rose in my husband's lapel?

everything

nice

NARRATIVE IN GLASS

The need to tell a story or document an emotion often fuels the creative process. Since the language of the artist is limited by his or her chosen medium, it is little wonder that so many contemporary artists have chosen to express their personal statements in glass, as it offers such a wide diversity of options.

Narrative work in glass spans the range from social commentary to mythological story telling. Glass may be the perfect material for narrative because its range of manipulation and ability to imitate other materials is like no other substance. Hot glass is perfect for capturing the smooth lines of the human form, while its fluidity and implied motion amplify our ability to examine the human condition. With cast glass, an artist can reproduce textures and shapes, whether from nature or from common objects, to make subtle or explicit statements about the world in which we live. The incorporation of glass canes (stretched rods of glass) and of fused and flameworked elements into the mass of glass allow the artist to "illustrate" with contrasting colors and shapes. At the other end of the spectrum, cold glass, with its smooth surface, is a waiting canvas for the painted image or written word. By constantly reinventing and experimenting with new techniques and combining glass with other materials, artists are further expanding the scope of their possibilities: glass and stone, glass and metal, glass and wood, even glass and fiber.

It is this capacity for expression, coupled with greater accessibility, which has been responsible for the growth of the glass field over the last few decades. New artists continue to enter the field, undaunted by preconceptions and stimulated by their need to communicate and by the infinite magical possibilities of the material. Whether figurative or abstract, miniature or monumental, a solitary form or a multi-part installation, glass will remain a vibrant and satisfying medium.

Susie Krasnican, *Sugar, Spice And Everything Nice!*, 1998, sandblasted and enameled glass, 35$^{3}/_{8}$"H x 16$^{1}/_{2}$"W x$^{1}/_{2}$"D overall. Krasnican says, "Sometimes I think of myself as a storyteller who uses a vocabulary of objects familiar to us all, constructing and combining elements in such a way as to make something noticeable out of something ordinary. I enjoy inviting people to look twice. The first time they see with their own experience, the second time with mine."

Photo by Mark Gulezion

Therman Statom

CHAPTER SIX

TITLE: Color Spirits, 1999
DESCRIPTION: Glass and mixed media
DIMENSIONS: 37"H x 26"W x 16"D

"I'm really interested in the painting and how I develop personal content in the work. A lot of the images have specific symbolic references and implications, but in many cases the reference can be emotionally based, rather than having a specific meaning."

— Therman Statom

Photo by Victor Bracke

NARRATIVE IN GLASS

Robin Grebe

Photo by James Beards

TITLE: Natural Selection
DESCRIPTION: Cast glass, slumped plate glass
DIMENSIONS: 28"H x 14"W x 7"D

"In my work, symbols are expressed mainly through mythological and metaphorical images. They symbolize both personal and common life experiences and thought processes that help me understand my relationship to the world. The figurative element acts as the setting or the canvas on which the images exist. Put in this figurative context, the images become metaphors for psychological and/or physiological states of being. It is these 'states of being' that tell autobiographical tales of my life."

— Robin Grebe

CHAPTER SIX

Michael Rogers • David Reekie

ARTIST: Michael Rogers
TITLE: Antonin Artaud Bottle, 1999
DESCRIPTION: Blown glass, engraved, bent nails
DIMENSIONS: 16"H x 7"Dia.

"The series of bottles involves portraying the bottle as a site, or a miniature environment much like a stage where a mood is set. In this environment, stories are told and emotions and thoughts contained. The overlaying of one word over another and the tactile quality of handwritten script on a transparent surface gives an impression of the fragility of words and the fleeting nature of definition."

— Michael Rogers

Photo by Elizabeth Beermsterboer-Rogers

ARTIST: David Reekie
TITLE: Sitting on the Fence II (detail), 2000
DESCRIPTION: Lost wax cast glass, galvanized, corrugated steel sheet and wood
DIMENSIONS: 66 1/8"H x 26 3/4"W x 21 1/4"D

"In recent years I have explored different relationships between people, and how they react to certain situations. Glass as a sculptural material has helped me give life and mystery to these inert situations, and adds a sense of fragility to my ideas and themes."

— David Reekie

Photo by David Reekie

NARRATIVE IN GLASS

Marc Petrovic

TITLE: Source
DESCRIPTION: Blown and hot sculpted glass, plate glass
DIMENSIONS: 31"H x 21"W x 7"D

"My work is a visual diary. I strive to make work that is provocative, yet quiet and peaceful. I like my pieces to serve as calming places, in contrast to the often hectic feeling of everyday life."

— Marc Petrovic

Photo by Cathy Carver

91

Deanne Sabeck

CHAPTER SIX

Photo by Deanne Sabeck

TITLE: Eros in the Basilica
DESCRIPTION: Reflective glass and photo imagery, light
DIMENSIONS: 14"H x 6"W x 4"D

"Eros in the Basilica was created to celebrate one of the most erotic, fortuitous and spontaneous moments in my life. While traveling in Italy, my boyfriend and I came upon an abandoned, bombed-out basilica. After crawling through a tunnel, we found ourselves in an underground chapel with an altar that was simply irresistible!"

— Deanne Sabeck

NARRATIVE IN GLASS

Mary Van Cline

TITLE: Ocean of Memory, 1999
DESCRIPTION: Pate de verre,
photosensitive glass
DIMENSIONS: 22"H x 35"W x 6"D

TITLE: The Receding Nature
of Time, 1998
DESCRIPTION: Pate de verre,
photosensitive glass
DIMENSIONS: 20"H x 24"W x 6"D

"Time is the riddle of human existence. It pushes one forward and leaves one behind. It exists beyond clocks, but humanity is constantly trying to measure it. Its boundaries can drive one to despair; its passage heal. [These] sculptures depict man's wish to find a way to another time plane."

— Mary Van Cline

Henry Halem

CHAPTER SIX

TITLE: Sanctuary, 2000
DESCRIPTION: Glass box with reverse ink drawing, oil stick, beeswax over wood (pedestal object)
DIMENSIONS: 12½"H x 16"W x 16"D

"The work is not only about what meaning I, as an artist, bring to the object, but also about what meaning and emotion the viewer takes from the object. The total work of art is by design ambiguous. The key for all my works lies in new contextual values brought by the viewer to the object."

— Henry Halem

NARRATIVE IN GLASS

Judith La Scola

TITLE: Nightbird Fan With Apple Green Interior, 1999
DESCRIPTION: 5/8" industrial plate glass, vitreous pigments fired, precious metal leaf, paint, blown glass
DIMENSIONS: 16"H x 30"W x 8"D

"I am endlessly fascinated by the beautiful, simple shapes of the ancient tea bowls. My reference to these intimate forms is as life-giving, precious, nonfunctional objects. The work consists of two elements: the use of free-form bowls and a corresponding painting, created to resolve and complement a common element with the two. I associate the echoing of forms with regeneration."

— Judith La Scola

Dick Weiss • Walt Lieberman

CHAPTER SIX

ARTIST: Dick Weiss; Vessel Blown by Dante Marioni and Benjamin Moore
TITLE: Black and White Face, 1999
DESCRIPTION: Enamels fired onto blown glass
DIMENSIONS: 24"H

"I look at human faces — others, my own — a lot. They are very important to me. A vessel is an archetypal form. I love paint. I love glass. It seemed natural to combine them. This piece is a self-portrait and has the names of many of the people about whom I think often; the names crowd around my face and in many ways help define me."

— Dick Weiss

ARTISTS: Dick Weiss and Walt Lieberman
TITLE: The Veil, 1997
DESCRIPTION: Enamels on flat glass
DIMENSIONS: 24"H x 12"W

"We are engaged in a collaboration of painting and printmaking; there is no separation of functions. This means we are enmeshed in each other's work. It requires a great deal of flexibility and trust. We have similar interests in subject matter, but our approaches are different. Both of us find inspiration from Renaissance painting, this piece started as a copy of a portrait from that period. As we say only half-jokingly, we copy the best."

— Dick Weiss and Walt Lieberman

NARRATIVE IN GLASS

Tom McGlauchlin

Photo by Tom McGlauchlin

TITLE: The Woman in the Turtleneck, 1999
DESCRIPTION: Blown glass with crushed glass
DIMENSIONS: 15"H x 12"W x 4"D

"This piece represents a number of my friends and relatives who, in spite of severe medical adversity, found a fierce joy in being alive."

— Tom McGlauchlin

Kéké Cribbs

CHAPTER SIX

TITLE: Yellow Tail, 1999
DESCRIPTION: Reverse-fired enamels on glass, steel, copper
DIMENSIONS: 27"H x 24"W x 8"D

"My work has always been narrative and colorful. The narratives depicted on these forms represent the choices we make in this life, small vignettes into fictional lives that may remind one of a surreal dream or experience, a palpitation of the heart, a frozen moment in the emotional adventure of life."

— KéKé Cribbs

NARRATIVE IN GLASS

Susan Stinsmuehlen-Amend

TITLE: Welcome Couplet
DESCRIPTION: Glass, metals, velvet, gold and silver leaf on wood panels
DIMENSIONS: 24"H x 32"W

"I work like a painter, but I am compelled to use various techniques
and materials to vary the surface and texture of the work.
This inclusive approach creates a pictorial narrative that better
describes the complexity of life. The combination of unlikely images —
a surreal approach — suggests there is more to what we perceive.
What we see belies a hidden logic, the logic of dreams."

— Susan Stinsmuehlen-Amend

Ricky Bernstein

CHAPTER SIX

TITLE: Love Muffin, 1996
DESCRIPTION: Painted glass and aluminum, oil and acrylic paints, oil crayon, mixed-media objects
DIMENSIONS: 84"H x 84"W x 12"D

"As an artist, my job is to observe, digest and visually chronicle that which defines our society. I think of myself as a social satirist using poignant humor with a dose of sarcasm to get to the heart of an issue. Through vivid color, humorous characters and familiar content, I hope to firmly connect and engage the viewer within the story's web."

— Ricky Bernstein

NARRATIVE IN GLASS

Robert Carlson

TITLE: The Shulamite, 2000
DESCRIPTION: Blown glass,
enamel paint, gold leaf
DIMENSIONS: 36"H x 10½"Dia.

"The meanings in the symbolism will be as varied as the viewers, but an essential communication will take place, a communication on a subconscious level that thrills us and leaves us wondering, leaves us in the question that life itself is."

— Robert Carlson

101

Cappy Thompson

CHAPTER SIX

TITLE: I Dreamed That I Entered the Garden of the Soul
DESCRIPTION: Vitreous enamels, reverse painted on blown glass
DIMENSIONS: 15½"H x 14½"Dia.

"As an artist I am interested in dreams as windows to my imagination, my unconscious, my interior life. Sometimes dreams are made of the mundane stuff of everyday life, and sometimes they enter a realm of mythopoesis where images emerge in a narrative of symbolic events."

— Cappy Thompson

TITLE: Dream Tapestry
DESCRIPTION: Vitreous enamels, reverse painted on blown glass
DIMENSIONS: 15¾"H x 13½"Dia.

Photos by Michael Seidl

NARRATIVE IN GLASS

Judith Schaechter

TITLE: Autobiography, 2000
DESCRIPTION: Stained glass
DIMENSIONS: 25"H x 21"W

"The ideas I get while drawing are almost always the best stuff. They tend to override any concepts that 'sounded' good. No matter how much I love an idea, I'll sacrifice it for the look of the piece. I believe that in visual art, the bottom line, conceptually, is always the aesthetic."

— Judith Schaechter

Tracey Ladd

CHAPTER SIX

TITLE: Reflections on Summer's Passage, 2000
DESCRIPTION: Cast glass, mixed media
DIMENSIONS: 14"H x 7½"W x 7"D

"By utilizing my personal experiences, I formulate connections to the natural and physical world. These associations create a mirror for self-discovery and become a visionary glimpse of the soul's journey. By witnessing and reflecting, the viewer establishes the connected interpretation and completes the movement from the personal to the shared."

— Tracey Ladd

104

NARRATIVE IN GLASS

Naoko Takenouchi

TITLE: Grace
DESCRIPTION: Blown glass, metal, gravel, gold leaf
DIMENSIONS: 15"H x 10"W x 10"D

"Since leaving Japan ten years ago, I have devoted myself to glass making. It has been both my compass and the direction for my creative and intuitive life. My memories, like old friends, have been enclosed in glass to say good-bye to them, and I have moved on."

— Naoko Takenouchi

Stephen Paul Day

CHAPTER SIX

TITLE: Violetta
DESCRIPTION: Cast lead crystal glass, bronze
DIMENSIONS: 28"H x 14"W x 9"D

"I am fascinated by opera because it is a fusion of drama, music and visual arts. The mixture of media inspired this new series of work with opera as the theme. The women in opera embody love, passion and desire. This piece is dedicated to the diva from *La Traviata*."

— Stephen Paul Day

Photo by Will Drescher

NARRATIVE IN GLASS

Jamex de la Torre • Einar de la Torre

TITLE: Sinner's Lounge
DESCRIPTION: Blown glass and mixed media
DIMENSIONS: 26"H x 15"W x 15"D

"As Mexican-American bicultural artists, we are on the one hand influenced by the morbid humor of Mexican folk art, the absurd pageantry of Catholicism, and machismo; on the other hand, we are equally fascinated by the American culture of excess: its pornographic materialism, its blow-up-doll aesthetic and, most of all, its lingering Puritanism."

— Jamex de la Torre and
Einar de la Torre

Photo by William Nettles

GLASS AS SCULPTURE

From the 1960s, when glass was introduced into the art departments of major universities, it was intended to be a medium for the creation of sculpture. The diverse qualities inherent in glass make it an excellent choice. It can be clear and transparent for use as negative space in a composition, or opaque to reflect or absorb light. It can also achieve stunning visual effects, transmitting and transforming light. When hot, and almost liquid, glass can be shaped into an infinity of draped and curved forms. When a solid, it can be cut, polished, glued and constructed into elegant geometric compositions. The surface can be decorated with painting, sandblasting, acid etching and fusing. Often, the final outcome doesn't look like glass at all, transcending preconceptions of how glass can be used. All of these possibilities make glass an enigmatic and seductive medium for the contemporary artist.

Today's glass sculpture goes beyond its intriguing physical properties and, as with any other artistic form, it is the creative capacity of the artist — not the medium — that defines the work. In some ways, recent decades have been without the definitive contemporary art movements that have characterized most of the history of art. Works in traditional craft media, such as glass, are an exception. In the minds of many, they have been the most exciting and innovative areas of artistic expression and growth.

It is the talent of the artists that has taken works in glass beyond the constraints of the medium. They express a wide range of aesthetics, from minimalist forms to outlandish statements. Collectors, critics, curators and museums, from the Smithsonian to the Metropolitan Museum of Art, have recognized the importance of work made with glass. One sure sign of its success is that the work is seldom discussed in terms of material these days, but is viewed instead purely for its significance as art.

William Morris, *Rhyton: Bull With Frog and Bird,* blown glass, 15"H x 18"W x 9"D. "My work is about the symbolic meaning which is attributed to objects and/or artifacts from various cultures. Ordinary objects such as bone take on great cultural and spiritual significance, reflecting the values and beliefs of tribal man. Although my work is shaped by the influences of contemporary life and technology, it contemplates fragments from the past, reinventing the narrative of the hunt, stories and rituals which continue to live on in the artifacts which remain."

Photo by Rob Vinnedge

Leah Camille Wingfield

CHAPTER SEVEN

TITLE: To Intawella Market
DESCRIPTION: Cast crystal, paint, jewelry, wood boat
DIMENSIONS: 26½"H x 16"W x 7"D

"All of my work is driven by passion. Passion for my current subject. Passion for the material. Passion for working. I seek to capture a single moment in time, just a small part of a greater story. Ultimately, it is the consideration of the greater story that tickles the imagination."

— Leah Camille Wingfield

GLASS AS SCULPTURE

Robert Dane

Photo by Paul Turnbull

TITLE: Eleggua
DESCRIPTION: Blown glass, wood base
DIMENSIONS: 24"H x 6"W x 6"D

"There is an optimism inherent in my work which I have tried to reinforce in the face of a seemingly constant barrage of negativity and pessimism coming at us from many sources. My aim is to celebrate the beauty of the progression of life as it ever unfolds and reveals itself."

— Robert Dane

José Chardiet · Ginny Ruffner

CHAPTER SEVEN

ARTIST: José Chardiet
TITLE: Sombras
DESCRIPTION: Blown and cast glass
DIMENSIONS: 29"H x 13"W x 8¼"D

"My most recent research has focused primarily on designing and making glass sculptures using blowing and casting processes. Drawing from topics as diverse as Spanish still-life painting, woodwind instruments and African art, my goal is to create sculptures imbued with a spiritual inner life."

— José Chardiet

ARTIST: Ginny Ruffner
TITLE: Mobile Leaves, Virtual Vessel Series
DESCRIPTION: Steel and glass
DIMENSIONS: 78"H x 45"W x 23"D

"The combination of steel and glass provides me with both the dichotomy that fuels my art-making and a way around the inherent limitations of glass (scale and fragility). The *Virtual Vessel* series refers to both the vessel tradition in glass and the computer-world meaning of the word 'virtual,' i.e., simulating reality: in this case, an object that can carry something (like a traditional vessel can carry or hold something), but definitely not a vessel in the traditional sense."

— Ginny Ruffner

GLASS AS SCULPTURE

Latchezar Boyadjiev

Photo by Latchezar Boyadjiev

TITLE: Woman
DESCRIPTION: Cast glass
DIMENSIONS: 27"H x 25"W x 5"D

"I want my work to fit in contemporary architecture and environments, and to clearly reflect the modern era in which we live."

— Latchezar Boyadjiev

113

CHAPTER SEVEN

Hiroshi Yamano • Stephen Jon Clements

ARTIST: Hiroshi Yamano
TITLE: From East to West Fish in Water # 42
DESCRIPTION: Glass
DIMENSIONS: 9 7/8"H x 9"W x 8 5/8"D

"I like to keep moving and have different experiences. The memories I have from my experiences are my most important treasure. To keep getting my treasures, I have to keep swimming the world like a fish swimming in waters. I am a fish that is always looking for something. I am a fish that cannot stop swimming until my body stops moving. Maybe I will swim forever, like the universe does."

— Hiroshi Yamano

ARTIST: Stephen Jon Clements
TITLE: Blue Voyeur
DESCRIPTION: Cast glass and padauk wood
DIMENSIONS: 42"H x 8"W x 7"D

"Miss Dickie, my 2nd grade teacher, commented on my work, June 15, 1956,'I wish Stephen would take as much pride in the neatness of his papers as he does in his artwork.'"

— Stephen Jon Clements

GLASS AS SCULPTURE

Richard Jolley

TITLE: Sense of Self, 2000
DESCRIPTION: Blown and hot formed glass, fabricated and acid etched
DIMENSIONS: 51"H x 17½"W x 17½"D

"The many dualities of nature and materials interest me and I express this concern in my work by employing a figurative/narrative mode to document our times and environment. There is a classical/modern link in my work just as glass is a modern material with an ancient history."

— Richard Jolley

115

Mary Shaffer

CHAPTER SEVEN

TITLE: Float Back, 1999
DESCRIPTION: Slumped glass and metal
DIMENSIONS: 25½"H x 10"W x 6"D

"With the process I use in my work, mid-air slumping, I set up a structural system that lets the glass move freely as it starts to retain heat. This allows me to use gravity (the strongest force in the Universe) and an element of chance. The structural system I create permits the glass to move with fluidity and freedom. Because I work with gravity, I feel that I work with the forces of nature. The idea of yielding and joining forces of nature, versus the attitude of 'man over nature'; this is the fundamental philosophy behind my work."

— Mary Shaffer

Photo by Dan Morse

GLASS AS SCULPTURE

Herb Babcock

TITLE: Vortex #4, 1995
DESCRIPTION: Cast glass, steel and stone
DIMENSIONS: 35"H x 25"W x 22"D

TITLE: Pillared #35
DESCRIPTION: Cast glass, bronze and stone
DIMENSIONS: 45"H x 43"W x 24"D

"The *Pillared* series and the *Vortex* series have developed over the last ten years, and examine stacked forms in precarious balance. This work reflects my view of social and environmental conditions in the world and, ultimately, of myself. I attempt to convey an overall sense of stability while the balanced elements appear unstable. I try to push this image further: to the eventual interaction between chaos and order."

— Herb Babcock

117

Michael Pavlik

CHAPTER SEVEN

TITLE: Black and White Square with Double Blue (FFF)
DESCRIPTION: Cast, cut, polished glass
DIMENSIONS: 20"H x 20"W x 20"D

Michael Pavlik's geometric works in glass are perfect examples of the interplay of color, light and form. A National Endowment for the Arts grant recipient, Pavlik received his Master of Arts degree in Prague, Czechoslovakia.

GLASS AS SCULPTURE

Jon Kuhn

TITLE: 12th Octave, 1999
DESCRIPTION: Glass
DIMENSIONS: 16"H x 16"W x 16"D

"My philosophical concerns as expressed in glass over the past twenty years have been a reflection of my studies in meditation and internal development. My forms are simple. Using cubes, columns, triangles, cones and polygons, I focus on the interiors. As in meditation, we go within, seeking our soul; in the sculpture the cube at the center becomes a symbol of the soul or essence of the piece."

— Jon Kuhn

Kreg Kallenberger

CHAPTER SEVEN

TITLE: Keystone Mountain Range
DESCRIPTION: Glass, stone and oil paint
DIMENSIONS: 15"H x 36"W x 12"D

"Most recently, my work has focused on the theme of landscape. I have attempted not only to convey a visual image but, again, to express and suggest the experience of the landscape."

— Kreg Kallenberger

GLASS AS SCULPTURE

Colin Reid

TITLE: R889, 2000
DESCRIPTION: Optical glass and copper
DIMENSIONS: 39"H x 53"W x 13"D

"If I were to identify a single thread that runs through my work it would be nature. That is the source to which I return for inspiration and fresh material for my work. I currently work mainly in optical glass because I like its purity."

— Colin Reid

Cissy McCaa

CHAPTER SEVEN

TITLE: Temptation, Dysfunctional Goblet Series
DESCRIPTION: Lead crystal, didymium glass
DIMENSIONS: 14½"H x 12"W x 8"D

TITLE: Chameleon Goblet, Dysfunctional Goblet Series
DESCRIPTION: Lead crystal, 4" aqua sphere, aqua and amber glass
DIMENSIONS: 18"H x 12"W x 10"D

"In Renaissance Europe, the ceremonial glass goblet was raised to a sophisticated, courtly art celebrating major events of the royal families. The 'dysfunctional goblet' grew out of my desire to make a social comment about our society and our use of the word 'dysfunction' to describe so many aspects of our culture — family, relationship, jobs, children and society itself. The sculptures are a celebration of our dysfunction."

— Cissy McCaa

GLASS AS SCULPTURE

Steven Weinberg

TITLE: Anawan Marsh Boat, 2000
DESCRIPTION: Cast crystal boat,
five air bubbles
DIMENSIONS: 7"H x 14"W x 6"D

TITLE: West Island Boat, 2000
DESCRIPTION: Cast crystal boat,
five air bubbles
DIMENSIONS: 7"H x 14"W x 6"D

"I work with the vessel today, to transform it with two incarnations. The first is that of a structure designed to travel on water, the boat. The second is that of the buoy. With both the boat and the buoy, I create a new, though referential, entity. Although quite different in character, the two forms relate visually in the way they say 'vessel.'"

— Steven Weinberg

Photos by Douglas Schaible

123

Mark Peiser

CHAPTER SEVEN

TITLE: Second Study for Contrition, 2000
DESCRIPTION: Cast glass
DIMENSIONS: 6½"H x 7"W x 6½"D

"I try to be totally aware of the whole situation of a piece and try to be objective about what I end up with and what it should be."

— Mark Peiser

GLASS AS SCULPTURE

Paul Seide

Photo by Noel Alum

TITLE: Aloumina, 1996
DESCRIPTION: Blown glass filled with neon gas
DIMENSIONS: 17½"H x 19"W x 18"D

"It is a very basic or primal event when these sculptures glow with excited plasma. The form is empty and then it is full of light, and the light is being created the way light is created in a star or the aurora borealis or a comet. I considered these sculptures more than forms moving through space; they are also a phenomena of light and color."

— Paul Seide

125

Photo by Christophe Lehman

CONTRIBUTING ARTISTS

Loy Allen
Page 62

Avery H. Anderson
Page 57

Herb Babcock
Pages 10, 117

Philip Baldwin
Page 126

Gary Beecham
Page 40

Ricky Bernstein
Page 100

Sonja Blomdahl
Page 49

Latchezar Boyadjiev
Page 113

Vernon Brejcha
Page 13

Jane Bruce
Page 10

Jaroslava Brychtová
Page 27

Lucio Bubacco
Page 21

George Bucquet
Page 67

Ellie Burke
Page 59

Ann Alderson Cabezas
Page 52

Robert Carlson
Pages 55, 101

William Carlson
Page 12

Sydney Cash
Page 13

José Chardiet
Page 112

Victor Chiarizia
Page 53

Phyllis Clarke
Page 58

Stephen Jon Clements
Page 114

Jeremy R. Cline
Page 4

Michael Cohn
Page 83

Anthony Corradetti
Page 34

Stephan J. Cox
Page 77

Kéké Cribbs
Page 98

Dan Dailey
Pages 13, 43

Robert Dane
Page 111

Stephen Paul Day
Page 106

Einar de la Torre
Page 107

Jamex de la Torre
Page 107

Laura Donefer
Page 45

Fritz Dreisbach
Pages 2-3

Bandhu Scott Dunham
Page 73

Erwin Eisch
Page 9

Shane Fero
Page 63

Hans-Godo Fräbel
Page 70

Kyohei Fujita
Page 20

Gary Genetti
Page 49

Michael Glancy
Page 15

William Glasner
Page 85

Jeri Goodman
Page 56

Dari Gordon
Page 81

Robin Grebe
Page 89

Peter Greenwood
Page 25

Monica Guggisberg
Page 126

Henry Halem
Pages 12, 94

Colin Heaney
Page 128

Sidney R. Hutter
Page 64

Richard Jolley
Page 115

Kreg Kallenberger
Page 120

Bernard Katz
Page 82

Robert Kehlmann
Page 12

Thomas P. Kelly
Page 83

Gene H. Koss
Page 15

Susie Krasnican
Page 86

Jon Kuhn
Page 119

Judith La Scola
Page 95

Tracey Ladd
Page 104

John Leighton
Page 47

Robert Levin
Page 35

Stanislav Libenský
Page 27

Walter Lieberman
Page 96

Marvin Lipofsky
Pages 8, 37

Harvey K. Littleton
Pages 6, 36

John Littleton
Page 30

Paul Marioni
Page 10

Dante Marioni
Page 29

Richard Marquis
Page 11

Steven Maslach
Page 76

Cissy McCaa
Page 122

Tom McGlauchlin
Pages 14, 97

Dimitri Michaelides
Page 28

William Morris
Front cover, pages 1, 108

Ralph Mossman
Page 18

Jay Musler
Page 65

Joel Philip Myers
Page 14

Margaret Oldman
Page 66

Markian Olynyk
Page 78

Leslie K. Ott
Page 84

Michael Pavlik
Page 118

Mark Peiser
Pages 7, 124

Flo Perkins
Page 46

Marc Petrovic
Pages 61, 91

Thomas Philabaum
Page 44

Bruce Pizzichillo
Page 81

Susan Plum
Page 71

Stephen Rolfe Powell
Page 41

Seth Randal
Page 72

David Reekie
Page 90

Colin Reid
Page 121

Douglas James Remschneider
Page 69

Richard Ritter
Page 33

Michael Rogers
Page 90

Richard Royal
Page 38

Ginny Ruffner
Page 112

Kari Russell-Pool
Page 61

Mariusz Rynkiewicz
Page 80

Deanne Sabeck
Page 92

Judith Schaechter
Page 103

Michael Schunke
Page 48

David Schwarz
Page 32

Paul Seide
Page 125

Mary Shaffer
Page 116

Josh Simpson
Pages 39, 74

Sam Stang
Page 24

Paul J. Stankard
Page 60

Therman Statom
Page 88

Susan Stinsmuehlen-Amend
Page 99

Harry Stuart
Page 19

Lino Tagliapietra
Pages 14, 16

Naoko Takenouchi
Page 105

Cappy Thompson
Page 102

Gianni Toso
Pages 11, 68

Ann Troutner
Page 42

Takeshi Tsujino
Page 22

Bertil Vallien
Page 23

Mary Van Cline
Page 93

David Van Noppen
Page 79

Kate Vogel
Page 30

Janusz Walentynowicz
Page 26

Steven Weinberg
Pages 50, 123

Dick Weiss
Page 96

Elizabeth Westerman
Page 84

Leah Camille Wingfield
Page 110

Hiroshi Yamano
Page 114

Mary Ann "Toots" Zynsky
Page 54

OPPOSITE: Philip Baldwin and Monica Guggisberg, *Cortigiane e Guardiani*, blown and carved glass, steel stands, tallest 90"H, shortest 77"H

ACKNOWLEDGMENTS

The authors would like to thank Toni Sikes and her entire team, particularly our patient and thoughtful editors, Katie Kazan, Anne McKenna and William Warmus, and our book designer, Cheryl Smallwood-Roberts. Our dedicated staff gave us their support as well as their skill; without them this book would not exist – Kirsten Muenster, Sheryl Wallace, Sioux Ashe, Miki Leier, Eveline Semel, Antonella Greco, Laren Hockinson, and most especially Magdalena Mazurek.

A great many people came to our aid during the research and writing of this book. Martha Drexler Lynn and Marvin Lipofsky graciously shared their expertise and resources. The book would not have been possible without the generous and knowledgeable help we received from the owners, directors and staff of galleries devoted to the exhibition of this wonderful medium. They include: Bonnie Marx, Marx-Saunders Gallery, Chicago IL; Maurine Littleton, Maurine Littleton Gallery, Washington DC; Amy Morgan, Morgan Contemporary Glass Gallery, Pittsburgh, PA; Terry Davidson, Leo Kaplan Modern, New York, NY; Ellie Miller, Miller Gallery, New York, NY; Bruce Hoffman, Snyderman Gallery, Philadelphia, PA; Carole Hochman, Barry Friedman Ltd, New York, NY; Ferdinand Hampson, Habatat Gallery, Ponitac, MI; John Cram, Blue Spiral Gallery, Asheville, NC. In addition several artists and collectors, including Jean Sosin, Esther Anderson, Ricky Bernstein, Herb Babcock, Cissy McCaa and Robert Carlson, gave us their insights and unique points of view.

Most importantly our thanks go to all of the artists who have created and shared their work with us. They give life to the color, light and form which is contemporary glass.

Colin Heaney, *Black Lava Petroglyph*, 2000, blown and carved glass, 15"H x 15"W x 7¹/₈"D.